A Christmas Dinner

A Christmas Dinner by Charles Dickens

Foreword Copyright ©2008 by Peter Ackroyd

Menus & Recipes by Alice Ross Illustrations by Sharon Stein

Book Design by Susan Smilanic and Ally Crilly

Art enhancement by Sheri Worth

Copyright ©2008 by Red Rock Press

Engraving of Charles Dickens by William G. Jackmen, ca. 1840, © Bettmann/Corbis

Red Rock Press
New York, New York

www.RedRockPress.com

Library of Congress Cataloging-in-Publication Data

A Christmas dinner by Charles Dickens / foreword by Peter Ackroyd ; menus
and recipes by Alice Ross.
 p. cm.
 The story "A Christmas dinner" first appeared in Sketches by Boz in 1836
after being published as "Christmas Festivities" in a periodical
entitled Bell's Life in London in 1835.
 This book comprises the short story, A Christmas dinner, by Charles
Dickens, the history of English Christmas customs and foods, and recipes
for foods served at Christmas.
 ISBN 978-1-933176-10-9
 1. Christmas--Great Britain –History –19th century. 2. Christmas
cookery. 3. Cookery, British. 4. Great Britain –Social life and
customs –19th century. I. Dickens, Charles, 1812-1870. Sketches by Boz.
Christmas dinner. II. Ackroyd, Peter, 1949- III. Ross, Alice.
 GT4987.43.C47 2007
 394.26630941 –dc22
 2006037152

Printed in China

A Christmas Dinner

by Charles Dickens

Foreword by Peter Ackroyd
Illustrations by Sharon Stein
Menus and Recipes by Alice Ross

Red Rock Press New York, New York

Would that Christmas lasted a whole year through (as it ought).

Charles Dickens
London, 1835

Table of Contents

Foreword

'Christmas Festivities," written by Charles Dickens, appeared in December 1835 in a periodical entitled *Bell's Life in London*. Under the title of "A Christmas Dinner" it was republished early in the following year as one of the *Sketches by Boz*, "Boz" being the pseudonym that the young Dickens had adopted. He was twenty-three at the time of the story's original publication but, at that early age, he had already become a noted and original journalist; his sketches of "everyday life" and "everyday people," as one critic noted, had won great acclaim for their realism and humour.

He was soon to begin writing *The Pickwick Papers* but already, in sketches such as "A Christmas Dinner," we can see the lineaments of his mature style. Dickens was finding his enduring themes as he went along, working with impetuous enthusiasm and extraordinary energy. Here is the first reference to the "misanthrope" who does not enter the blessed spirit of Christmas, a type who would come to glorious fulfilment in the figure of Ebenezer Scrooge. And then, in his depiction of "the merry faces of your children" at Christmas, he mentions the possibility that "one little seat may be empty, one slight form that gladdened the father's heart. This is a direct anticipation of the episode of Tiny Tim in "A Christmas Carol,"

but in this earlier tale we see how Dickens instinctively combined pathos with comedy, the poignant with the benevolent.

*I*t would not be true to say that Dickens invented Christmas but he, more than any other writer, helped to communicate its secular and humanitarian gospel. It would seem that cheerfulness was the key. One of his favourite expressions was "Never say die," and the optimism of his nature is to be found within this story. He lent Christmas the aura of what he once called the "cheerful discharge of duty, kindness and forebearance." The Christmas spirit in his writing was, in fact, only indirectly related to the religious spirit. The birth of the Christian saviour is nowhere mentioned in his account of this festival. Instead, his was the spirit of common humanity. It is manifest here in the reconciliation between an erring daughter and a mother, one of those sentimental reunions that Dickens could never resist.

*C*hristmas had always been a time of ritual feasting and gift-giving, but Dickens placed the festivities firmly within the family circle. He was about to begin a young family of his own, with his imminent marriage to Catherine Hogarth, but the idea of family was already central to his identity. His own family had been torn apart, at the time of his father's incarceration for debt in the Marshalsea Prison, and all his life he tried in his fiction to repair the damage. That is why he transformed the idea of Christmas by investing it with his own particular mixture of aspirations, memories and fears. He made it comfortable; he made it cosy; he made it immune to the threatening world outside. It became the celebration of a small and close-knit community within a lighted room.

*S*o here we have the mince pies, and the turkey from Newgate market, the Christmas pudding with its sprig of holly on the top, and the indispensable branch of mistletoe with which to inveigle the younger

members of the party. It is one of Dickens' most typical scenes, to be repeated soon after in the episodes at Dingley Dell in The Pickwick Papers as well as in the final scenes of "A Christmas Carol."

Dickens was also the first writer in English to present, in a direct and uncomplicated manner, the life and habits of what were then known as the "middling sort." These are the respectable middle-class people of the London world, who before this time had never seen their image on the printed page. That is why they became Dickens' largest and most enduring audience. Here they are described in an entirely uncondescending manner. Dickens did not condescend to them because he was, in large measure, one of them. He is a strikingly original writer because he observed, and wrote about, the world all around him.

There were of course certain elements missing in the English celebration of Christmas in the early nineteenth century. There was no Christmas tree. It was not introduced in English homes until the 1840s. There were no Christmas cards; they also did not appear until the 1840s. And there was not the English Yuletide accessory, the Christmas cracker. Instead there were multifarious games, parlour games such as Forfeits (the wrong answer costs), Charades and Blind Man's Buff, and the then familiar handcrafted board games such as Hare and Hounds, and Pegging, as well as games such as cribbage and backgammon. There were multifarious songs, too, their presence a reminder of the distance between Dickens's characters and ourselves. Who can imagine members of a family singing to each other around a modern Christmas dinner-table?

Dickens became identified with Christmas in the public imagination. More importantly, he identified himself with that festival. He memorialised it in "A Christmas Carol," the single most important fairy tale

of the nineteenth century, but he also continued his association in a series of Christmas books which followed that masterpiece. Dickens' image of Christmas, of beneficence and communal happiness never left him. It was for him the paradigm of an ideal human society, a society held together by mutual respect and mutual responsibility–with plenty of turkey and mince pies thrown in. So in "A Christmas Dinner" we see the beginnings of Dickens' genius.

Peter Ackroyd
London

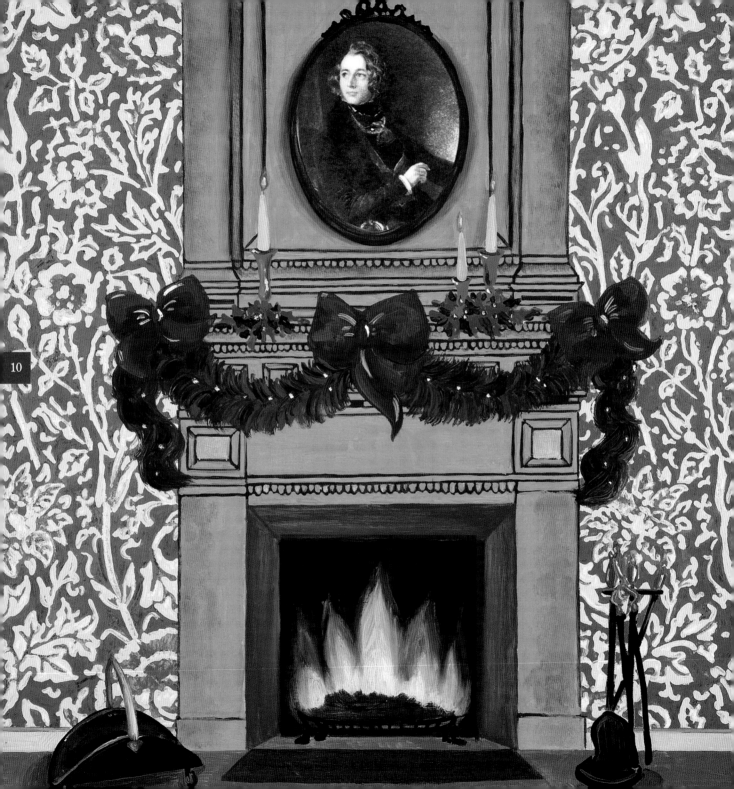

A Christmas Dinner

Christmas time! That man must be a misanthrope indeed, in whose breast something like a jovial feeling is not roused— in whose mind some pleasant associations are not awakened— by the recurrence of Christmas.

There are few men who have lived long enough in the world, who cannot call up such thoughts any day in the year.

Then do not select the merriest of the three hundred and sixty-five for your doleful recollections, but draw your chair nearer the blazing fire. Fill the glass and send round the song—and if your room be smaller than it was a dozen years ago, or if your glass be filled with reeking punch, instead of sparkling wine, put a good face on the matter, and empty it off-hand, and fill another, and troll off the old ditty you used to sing, and thank God it's no worse.

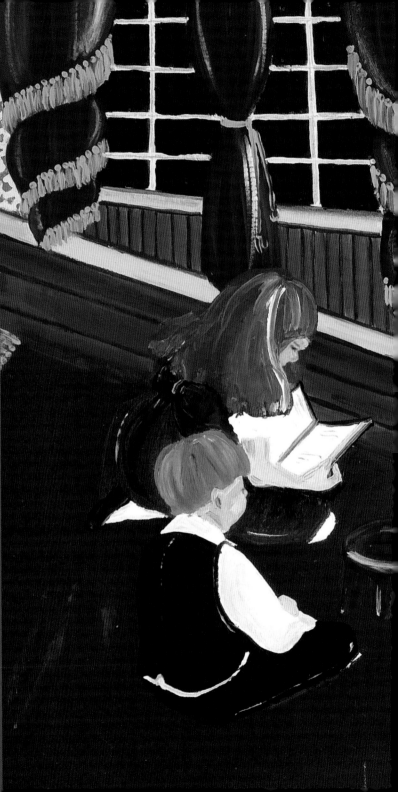

\mathcal{L}ook on the merry faces of your children (if you have any) as they sit round the fire. One little seat may be empty; one slight form that gladdened the father's heart, and roused the mother's pride to look upon, may not be there.

Dwell not upon the past; think not that one short year ago, the fair child now resolving into dust, sat before you, with the bloom of health upon its cheek, and the gaiety of infancy in its joyous eye. Reflect upon your present blessings---of which every man has many---not on your past misfortunes, of which all men have some. Fill your glass again, with a merry face and contented heart. Our life on it, but your Christmas shall be merry, and your new year a happy one! Who can be insensible to the outpourings of good feeling, and the honest interchange of affectionate attachment, which abound at this season of the year?

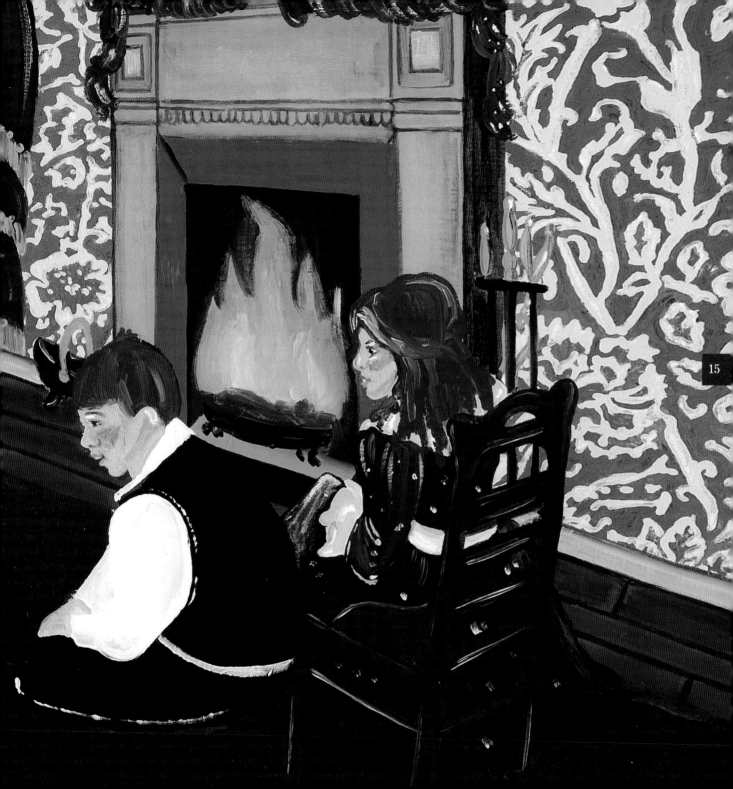

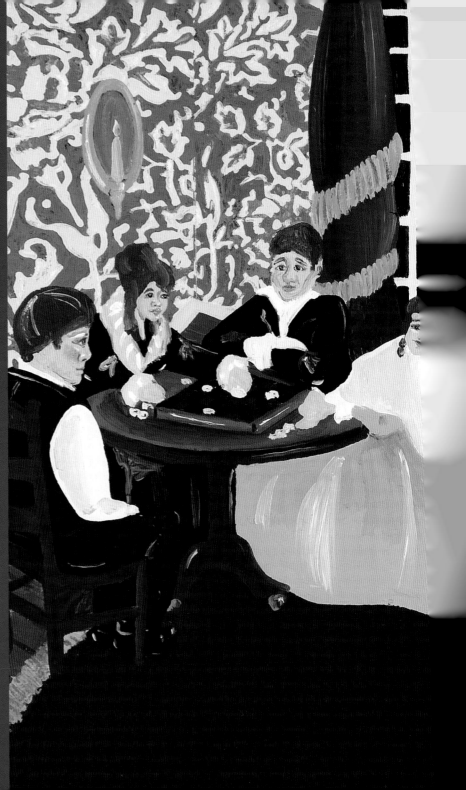

There seems a magic in the very name of Christmas.

Petty jealousies and discords are forgotten; social feelings are awakened in bosoms to which they have long been strangers; father and son or brother and sister, who have met and passed with averted gaze, or a look of cold recognition, for months before, proffer and return the cordial embrace, and bury their past animosities in their present happiness. Kindly hearts that have yearned towards each other, but have been withheld by false notions of pride and self-dignity, are again reunited, and all is kindness and benevolence!

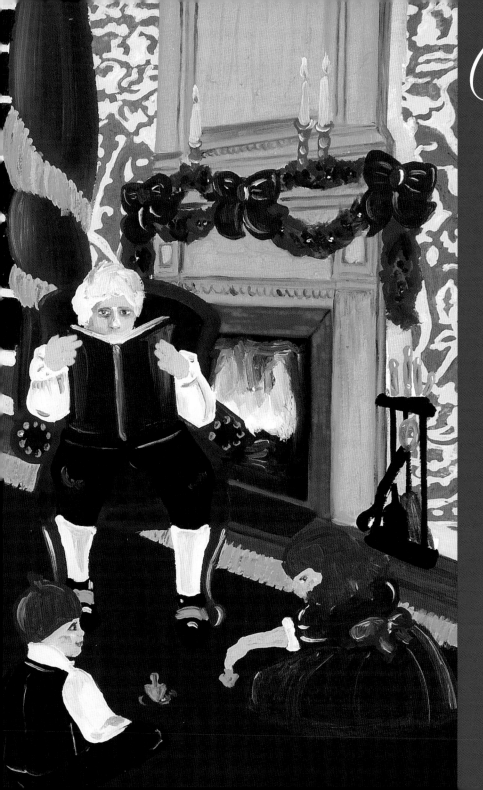

Would that Christmas lasted the whole year through (as it ought), and that the prejudices and passions which deform our better nature, were never called into action among those to whom they should ever be strangers!

The Christmas family-party that we mean, is not a mere assemblage of relations, got up at a week or two's notice, originating this year, having no family precedent in the last, and not likely to be repeated in the next. No. It is an annual gathering of all the accessible members of the family, young or old, rich or poor; and all the children look forward to it, for two months beforehand, in a fever of anticipation.

Formerly, it was held at grandpapa's; but grandpapa getting old, and grandmamma getting old too, and rather infirm, they have given up house-keeping, and domesticated themselves with Uncle George; so, the party always takes place at Uncle George's house, but grandmamma sends in most of the good things, and grandpapa always will toddle

down, all the way to Newgate Market, to buy the turkey, which he engages a porter to bring home behind him in triumph, always insisting on the man's being rewarded with a glass of spirits, over and above his hire, to drink "a Merry Christmas and a Happy New Year" to Aunt George.

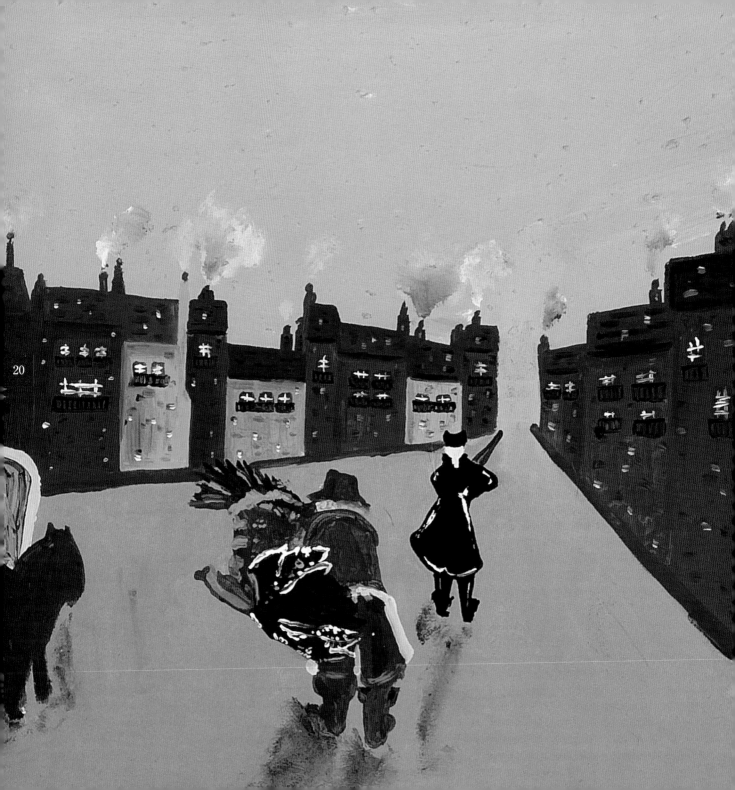

As to grandmamma, she is very secret and mysterious for two or three days beforehand, but not sufficiently so, to prevent rumors getting afloat that she has purchased a beautiful new cap with pink ribbons for each of the servants, together with sundry books, and pen-knives, and pencil-cases, for the younger branches; to say nothing of divers secret additions to the order originally given by Aunt George at the pastry-cook's, such as another dozen of mince-pies for the dinner, and a large plum-cake for the children.

On Christmas Eve, grandmamma is always in excellent spirits, and after employing all the children, during the day, in stoning the plums, and all that, insists, regularly every year, on Uncle George coming down into the kitchen, taking off his coat, and stirring the pudding for half an hour or so, which Uncle George good-humouredly does, to the vociferous delight of the children and servants.

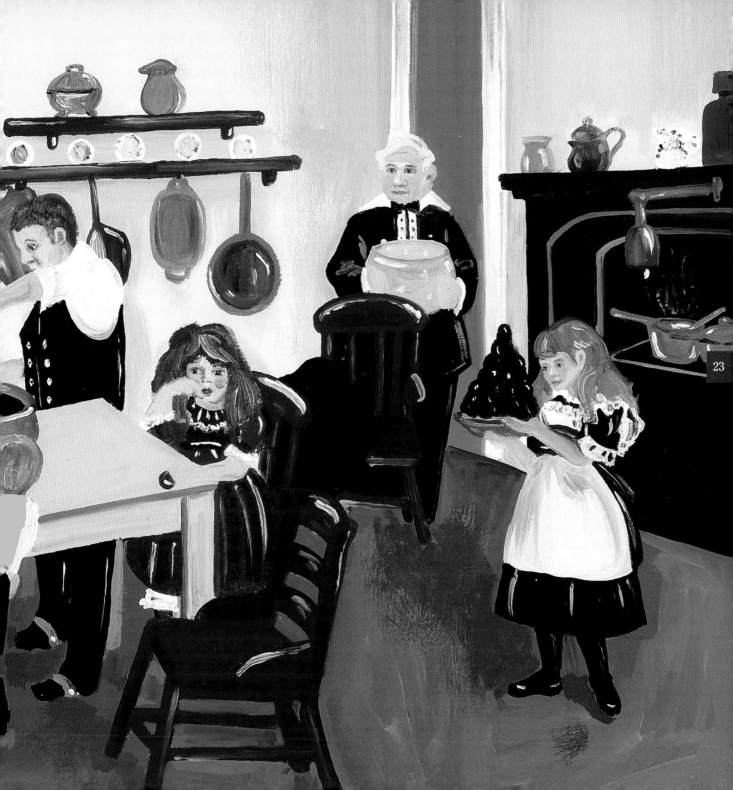

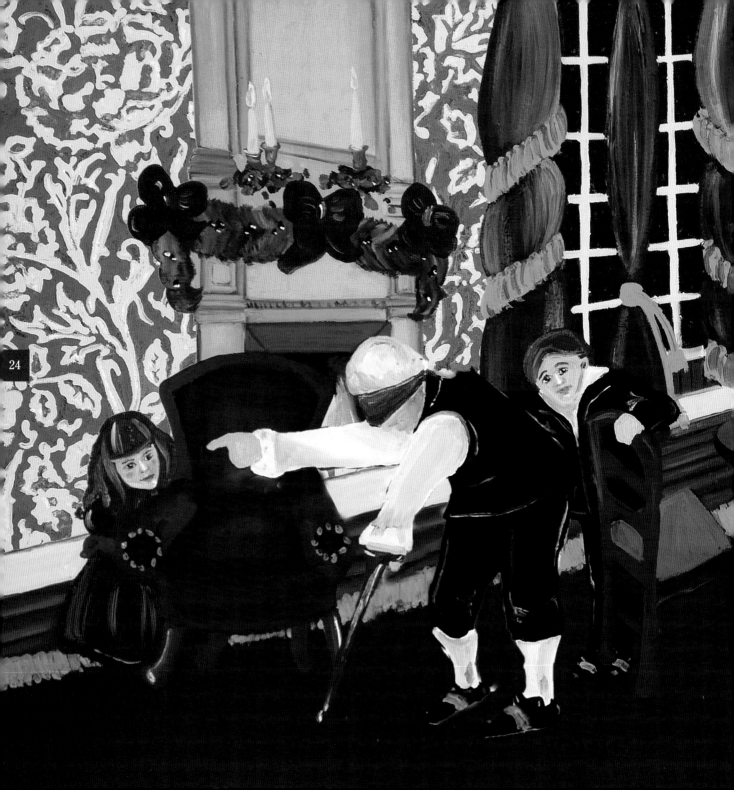

The evening concludes with a glorious game of blind-man's-buff, in an early stage of which grandpapa takes great care to be caught, in order that he may have an opportunity of displaying his dexterity.

On the following morning, the old couple, with as many of the children as the pew will hold, go to church in great state: leaving Aunt George at home dusting decanters and filling casters, and Uncle George carrying bottles into the dining-parlour, and calling for corkscrews, and getting into everybody's way.

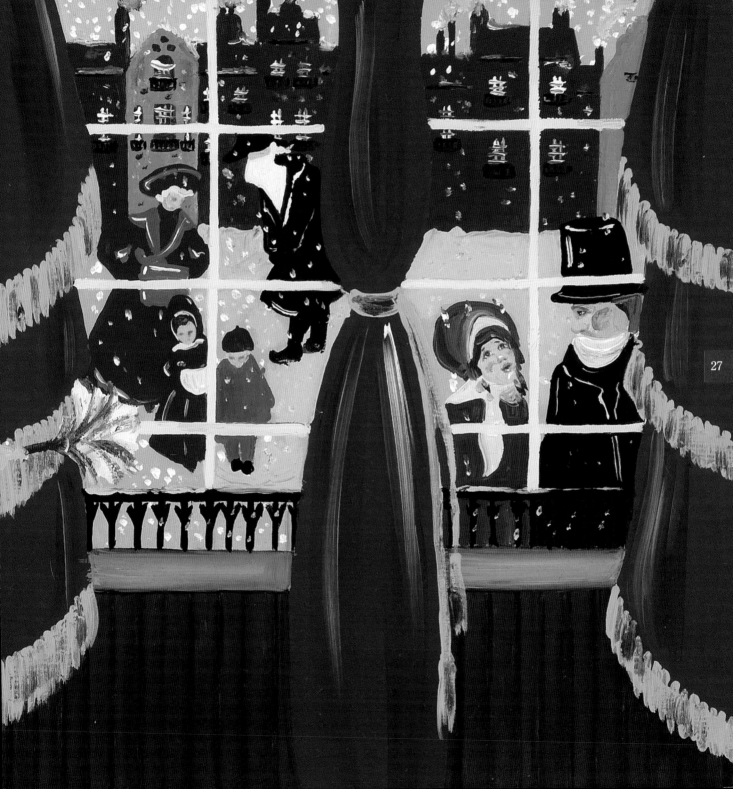

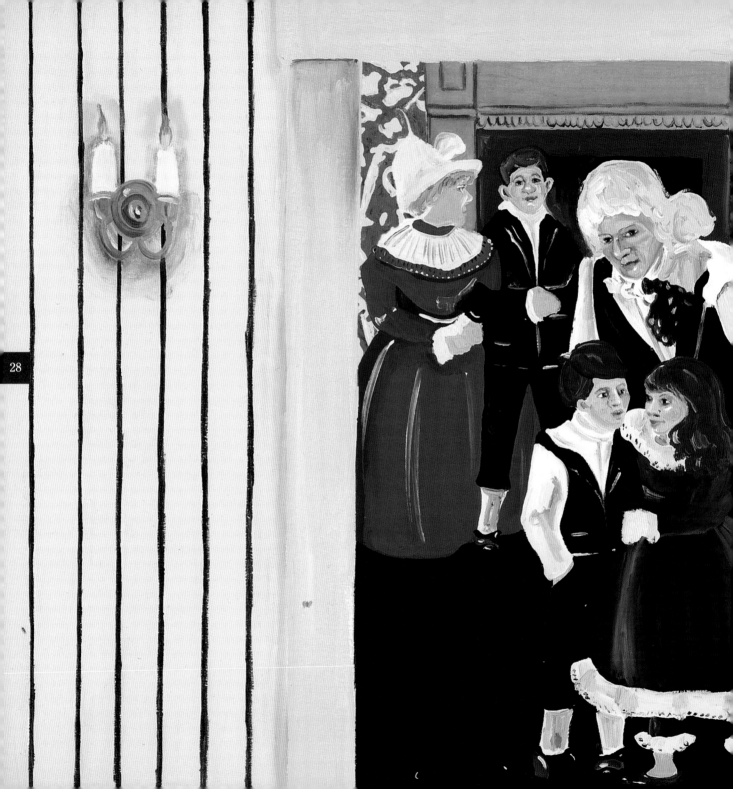

When the church-party return to lunch, grandpapa produces a small sprig of mistletoe from his pocket, and tempts the boys to kiss their little cousins under it—a proceeding which affords both the boys and the old gentleman unlimited satisfaction, but which rather outrages grandmamma's ideas of decorum, until grandpapa says, that when he was just thirteen years and three months old, he kissed grandmamma under a mistletoe too, on which the children clap their hands, and laugh very heartily, as do Aunt George and Uncle George; and grandmamma looks pleased, and says, with a benevolent smile, that grandpapa was an impudent young dog, on which the children laugh very heartily again, and grandpapa more heartily than any of them.

But all these diversions are nothing to the subsequent excitement when grandmamma in a high cap, and slate-colored silk gown; and grandpapa with a beautifully plaited shirt-frill, and white neckerchief; seat themselves on one side of the drawing-room fire, with Uncle George's children and little cousins innumerable, seated in the front, waiting the arrival of the expected visitors.

 \mathscr{S} uddenly a hackney-coach is heard to stop, and Uncle George, who has been
looking out of the window, exclaims, "Here's Jane!"--on which the children rush
to the door, and helter-skelter downstairs; and Uncle Robert and Aunt Jane, and the
dear little baby, and the nurse, and the whole party, are ushered up-stairs amidst
tumultuous shouts of "Oh, my!" from the children, and frequently repeated warnings
not to hurt baby from the nurse.

And grandpapa takes the child, and grandmamma kisses her daughter, and the confusion of this first entry has scarcely subsided,

31

when some other aunts and uncles with more cousins arrive, and the grown-up cousins flirt with each other, and so do the little cousins too, for that matter, and nothing is to be heard but a confused din of talking, laughing and merriment.

A hesitating double knock at the street-door, heard during a momentary pause in the conversation, excites a general inquiry of "Who's that?" And two or three children, who have been standing at the window, announce in a low voice, that it's "poor Aunt Margaret." Upon which, Aunt George leaves the room to welcome the newcomer; and grandmamma draws herself up, rather stiff and stately; for Margaret married a poor man without her consent, and poverty not being a sufficiently weighty punishment for her offence, has been discarded by her friends, and debarred the society of her dearest relatives.

But Christmas has come round, and the unkind feelings that have struggled against better dispositions during the year, have melted away before its genial influence, like half-formed ice beneath the morning sun. It is not difficult in a moment of angry feeling for a parent to denounce a disobedient child; but, to banish her at a period of general goodwill and hilarity, from the hearth, round which she has sat on so many anniversaries of the same day, expanding by slow degrees from infancy to girlhood, and then bursting, almost imperceptibly, into a woman, is widely different. The air of conscious rectitude and cold forgiveness, which the old lady has assumed, sits ill upon her; and when the poor girl is led in by her sister, pale in looks and broken in hope, not from poverty, for that she could bear, but from the consciousness of undeserved neglect and unmerited unkindness—it is easy to see how much of it is assumed.

A momentary pause succeeds; the girl breaks suddenly from her sister and throws herself, sobbing, on her mother's neck. The father steps hastily forward, and takes her husband's hand. Friends crowd round to offer their hearty congratulations, and happiness and harmony again prevail.

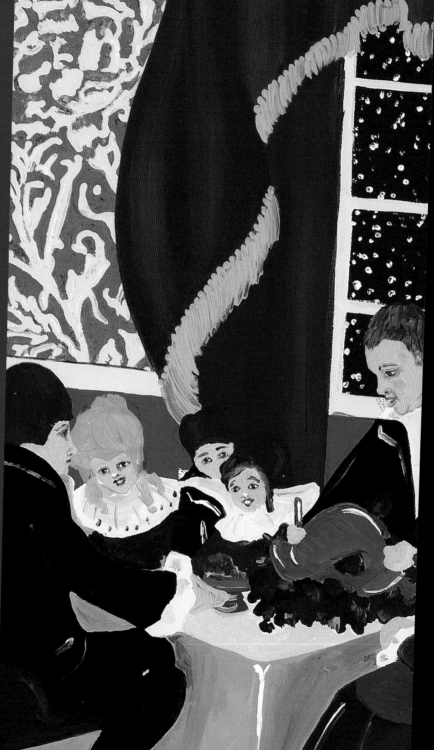

As to the dinner, it's perfectly delightful. Nothing goes wrong, and everybody is in the very best of spirits, and disposed to please and be pleased. Grandpapa relates a circumstantial account of the purchase of the turkey, with a slight digression relative to the purchase of previous turkeys, on former Christmas days which grandmamma corroborates in the minutest particular.

Uncle George tells stories, and carves poultry, and takes wine, and jokes with the children at the side-table, and winks at the cousins that are making love, or being made love to, and exhilarates everybody with his good humour and hospitality.

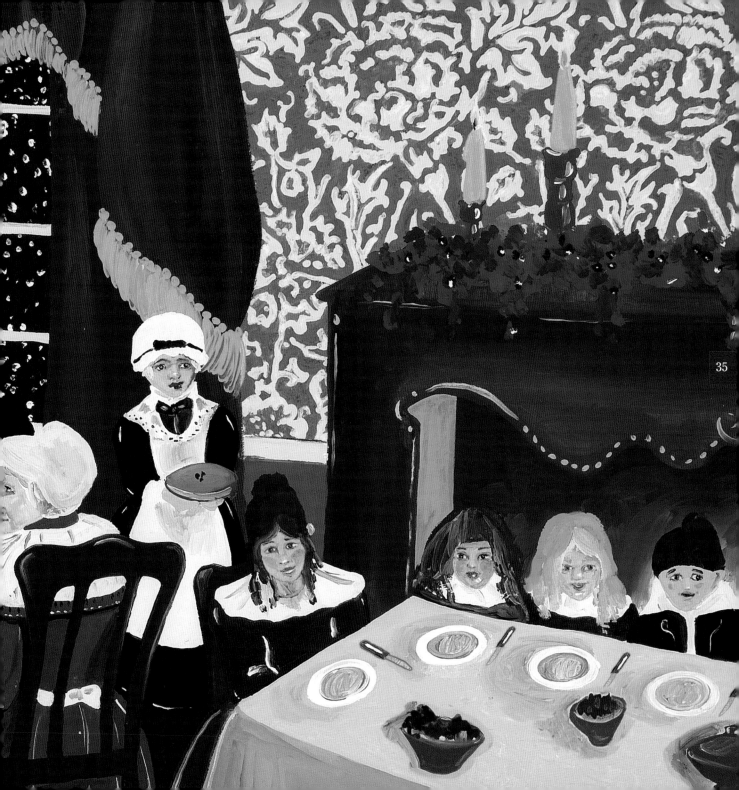

And when, at last, a stout servant staggers in with a gigantic pudding, with a sprig of holly in the top, there is such a laughing, and shouting, and clapping of little chubby hands, and kicking up of fat dumpy legs, as can only be equaled by the applause with which the astonishing feat of pouring lighted brandy into mince-pies, is received by the younger visitors.

Then the
dessert!
And the wine!
And the fun!

Such beautiful speeches, and such songs, from Aunt Margaret's husband, who turns out to be such a nice man, and so attentive to grandmamma!

Even grandpapa not only sings his annual song with unprecedented vigor, but on being honored with an unanimous ENCORE, according to annual custom, actually comes out with a new one which nobody but grandmamma ever heard before; and a young scapegrace of a cousin, who has been in some disgrace with the old people, for certain heinous sins of omission and commission – neglecting to call, and persisting in drinking Burton Ale – astonishes everybody into convulsions of laughter by volunteering the most extraordinary comic songs that ever were heard.

And thus the evening passes, in a strain of rational good-will and cheerfulness, doing more to awaken the sympathies of every member of the party in behalf of his neighbor, and to perpetuate their good feeling during the ensuing year, than half the homilies that have ever been written, by half the Divines that have ever lived.

The earliest Christmas celebrations in Britain had their roots in Druidic practices celebrating the mid-winter return of the lengthening day. Their icons were the yule log, the boar's head, holly, ivy and mistletoe. Feasting was a very important pastime.

By the Middle Ages, the boiled Christmas pudding and mince pies had put in their appearance. The celebrations continued (more in the halls of the wealthy than the hovels of the poor) until Cromwell's seventeenth–century revolt, when the Puritans turned away from festive religious display and pageantry.

The Anglican return brought back with it some of the festivities. Generally speaking, public celebrations withered as mushrooming changes overtook society, chief among them migration from close-knit rural communities to sprawling cities, the growth of manufacturing and the rigidity of strict class differences.

By the early nineteenth century, Christmas was an ordinary working day for most English laborers (as well as for most North Americans and Christians in various Commonwealth nations). A family might observe Christmas by attending a church service, but home celebrations were not universal. Neither Christmas Eve parties nor special Christmas dinners were the rule.

A young and still largely unknown English journalist begged to differ. In

1835, Charles Dickens wrote his first holiday sketch, the one you've just read. "A Christmas Dinner" not only presented Dickens' ideas of what we now call Christmas spirit, but also (drawing on remembered Christmas dinners at the home of his grandparents) suggested what Christmas celebrants might eat and drink, including roasted turkey, Christmas pudding, mince pies and holiday punch.

As Charles Dickens attracted fans, he greatly popularized the notion of the importance of Christmas dinner, and sparked a revival of traditional Christmas dishes.

The resurrection of a family Christmas celebration cannot be credited to Dickens alone. He would come to have help from a most influential source, Queen Victoria, who ascended the throne less than two years after the fledgling author had published his first fictional say on what Christmas ideally might be. The young queen, deeply in love with her German husband, Albert, imported to her palace elements of his childhood holidays, including Christmas stockings and trees, and cakes, cookies and candies. While we can now see all around us Queen Victoria's transplanted Christmas decorations, it was Dickens' insistence on traditional celebratory English foods at Christmastime that has prevailed at tables both in Britain and (to a lesser extent) wherever English is spoken at the table.

Some months after Dickens' first Christmas sketch was published, he took a wife, Catherine Hogarth, who'd been raised in Edinburgh and was no slouch as a cook. The couple soon opened their Doughty Street home in London to family and

friends with a splendid Christmas dinner. Their table surely sighed happily under the weight of soups, oysters galore, fish, turkey, roasted mutton and beef (all in rich sauces), numerous side dishes, rolls, butter and jam, desserts, toasted cheese and salad. All this food went down easily with brandy punch at the start, ales and wines during the meal, and sherry and port at the end.

The menu was a joint effort, as it appears that Charles and Catherine were equally fascinated by cooking. Although Catherine did some or all of the cooking in 1837, from 1838 onwards she employed a cook and kitchen staff who prepared the daily meals and assisted in numerous dinner parties.

After over a decade of married life, Catherine Dickens used a pen name to write a cookbook, *Lady Clutterbuck's What Shall We Have For Dinner?* A few of the dishes presented here, including Cock-A-Leekie Soup, come from that cookbook. Like the other recipes that follow, drawn from early nineteenth-century sources, they are also adapted for contemporary cooks.

In Dickens' world, Christmas dinner is certainly the main feast of the family Christmas season, but it was far from the only festive meal to be enjoyed. We present here a Christmas Eve menu as well as a Christmas dinner one, since the family's Christmas Eve party is of importance in this story.

There also would have been a Christmas Day breakfast and possibly also a lunch, not to mention Boxing Day sweets. Christmas celebrations included December 26, the date that came to be reserved in England for the exchange of gifts.

Breakfast the morning of Christmas Day was usually small, but in house-party situations it was probably large. Then it included such dishes as kippered fish, eggs, fried mashed-potato balls, deviled fowl,

kidney cutlets, pigeon pie, ham, pudding, fruit, bread, butter, jam or marmalade and, of course, tea. Upon returning home from church, the family might have partaken of a light luncheon, but more likely they awaited their large afternoon feast, that is, Christmas dinner.

Charles Dickens was not unorthodox in making turkey the highlight of the meal in "A Christmas Dinner." By his time, turkey had long been transplanted from the Americas and raised in England. The size of a turkey assured its centerpiece role in a festive holiday meal. Just before Christmas, there seem to have been plenty of turkeys for sale at Newgate Market, where the story specifies the grandfather was accustomed to purchasing the Christmas turkey. (The fact that in Dickens' later Christmas story, "A Christmas Carol," the Cratchett family dined on goose instead of turkey, likely has more to do with the small size of Tiny Tim's family and its tight budget than with any change of custom.) Not that a pride-of-place turkey was the only Christmas main-course meat for a prosperous family, whose holiday dinner also included lamb, beef and pork.

An inventory of kitchen goods made after Charles and Catherine had been married for eight years (and in a larger house situated in Devonshire Terrace) reveals a sizeable collection of iron, copper and tin pots, kettles, molds and other kitchenware. Not surprisingly, the equipment included an upright coal grate, coal shovel, tongs and poker to manage the fire. In its essentials, cookery in Dickens' day was no different from modern cooking, apart from the extra labor and time of making and tending fires.

Cooks learned to cook largely by their senses, experimentation and experience. The heat of the fire and of the contents of the pots was judged by its feel to the hands.

Taste, touch, sight, smell and sound were chief guideposts for judging a dish's progress. The system of using the senses and experience to judge the various stages of a dish was superior, in many ways, to the more precise measurements and procedures some of us use today, as it required a more intimate knowledge of properties of food. Recreating dishes from early nineteenth-century recipes reveals that the foods enjoyed by Dickens and his contemporaries must have been delicious.

Many of the settings in which these upper-middle class meals were served were also delightful. A dining room was set out with a central, large dining table, while sideboards and other serving tables backed against the walls. The latter held the beverages and their utensils: there might well have been several decanters and stoppers, wine baskets and corkscrews, and several sets of wine and water glasses. Elegant serving bowls and platters sat on dinner mats on the dining tables of the fashionable and affluent. Christmas dinner would be served on the family's best china.

The table was set for a seated buffet, the food arranged in strict geometric patterns, according to the then-current *service á la Français*. Period cookbooks, such as *The Female Instructor* or *Young Woman's Friend and Companion* diagrammed charts for placing the foods and the decorative candlestands that ornamented the table. The family Dickens portrays in "A Christmas Dinner" may have had somewhat more relaxed arrangements. Dickens never pinpoints where the Christmas party hosts, "Uncle George" and his wife, stand in the world of holiday tabletop fashions.

But however modern a table "Aunt George" set, it's clear that the Christmas

dinner described in this story is very much a family affair. All the children helped in making some desserts. Uncle George put his hand to stirring the Christmas pudding.

Together, the family would have entered the dining room for Christmas dinner, each adult claiming a seat at their table, while the children went to the table assigned to them. (With Charles Dickens as your mentor, you can assure your offspring that the idea of a children's table is a time-honored one.)

The first course of a meal began with important dishes of fish and soup at either end of the central table, with main dishes of meat at its center, and side dishes filling in. After the soup and fish had been consumed, servants took them away and replaced them with additional meat dishes.

In "A Christmas Dinner," the host, Uncle George, carves the turkey. But at a formal meal, the guest of honor might have been awarded that job. The other diners would have passed their plates to him if servants were not called upon for this task.

The quantity of food was so large and varied that no one was expected to eat everything, but rather to taste whatever took his or her fancy. Throughout the meal, servants offered beverages from the sideboard or serving table.

When the first course (which included everything but the desserts) was finished, hosts and guests left the dining room for entertainment or conversation elsewhere in the house. Meanwhile, the servants cleared the table, including the white tablecloth, only to reset the bare boards for dessert.

Alice Ross

Alice Ross
Smithtown, New York

Christmas Eve—in an England where social life was defined almost entirely by economic class—was the one occasion of the year upon which servants partied democratically with the family who employed them. In "A Christmas Dinner," the evidence of Uncle George stirring the Christmas pudding speaks volumes about the status lines that were crossed that one night in the kitchen.

The Christmas Eve party Charles Dickens delivers to us is a rowdy and boisterous scene, enlivened, no doubt, with beers, ales, ciders, gin punch and wassail. Gin was the drink of the working-class, served this night in a punch, made much like that of the brandy punch that the men of the family would enjoy the next day. (For punch recipes, see page 50.)

Wassail (from the Anglo-Saxon *waes hael* or *good health*) is the punch that remains most identified with Christmas. Its history—in earlier days it had been sipped by all and sundry from a large wooden bowl—goes nicely with the leveling spirit of the Christmas holiday. Wassail is a wondrous drink, a heated, spiced ale-wine-brandy concoction, served in Dickens' time with small, hot roasted apples bobbing in it. Wassail and hot, spiced elderberry wine were the two drinks exclusive to Christmas Eve.

Typically, at sundown on the twenty-fourth of December, the entire family joined the servants in the kitchen, where they arduously assembled the Plum Pudding (as Christmas Pudding is also known), drank, played games and partook of a substantial meal.

This supper was not the usual late-evening spread of cold meats and room-temperature leftovers from the large midday dinner, but something that was both hearty and especially prepared.

The recipe for Oyster Scollop (scalloped oysters) given here dates from a time when oysters were plentiful and cheap, although the dish was considered a festive one. Chicken pies were also much in fashion in 1835, made from the meat of hens, rich in flavor as all were free-range then. Carrots, which stored well in a root cellar, were a common enough side dish, as was a mix of mashed potatoes and turnips, made with milk, butter and salt to taste. (The English generally ate potatoes three times a day, a practice that persisted a decade later, even after the potato famine began in Ireland.) The Christmas Eve meal likely included an ordinary brown bread, unlike the white rolls served to the family the next day.

The Mincemeat Tarts listed on the menu are but smaller versions of the Mince Pie offered on the Christmas Day menu. The recipe for a pie is given here since that is probably what you will want to make at home.

As we know from the story, the grandmother ordered her pies and tarts from a bakery. That practice was common enough because of oven scarcity or limited capacity, and the relative expense of fuel for it. Had firewood or coal been less costly, the baking skill of the average British housewife would likely have been more developed. The fresh fruit still available in December, as well as nuts and cheese, would have rounded off the Christmas Eve meal.

Plenty of Gunpowder Tea would have been at hand. This tea was (and still is) imported from the Anhwei province of China and from Formosa. It takes its English name from its hand-rolled, tiny balls that look a bit like the coarse gunpowder of the early 1800s. (In China, it's called "Pearl Tea.") The speed with which Gunpowder Tea typically is processed, as well as its shape, assure its freshness beyond that of flat teas. The leaves are usually steamed and dried and rolled into balls within

ten hours of their picking. The flavor is invigorating, making Gunpowder a good choice for the late afternoon or evening. Gunpowder Green is available in bulk in Asian grocery shops, and should be brewed in the pot. However, any good quality green tea may be substituted for the Gunpowder variety.

Dickens vividly remembered the beginning of the holiday festivities from childhood Christmases at his grandparents' home. Such riotous games as "blind man's buff" (today, usually called "bluff") were played by adults and children alike as far back as the Middle Ages. For those who don't know it, the game is a tag in which the person who's "it" is blindfolded, but who must nonetheless tap and identify another player in order to pass on the blind-man role.

Another traditional game was snap-dragon, in which individuals, usually children in Dickens' time, were required to remove by hand the plums (raisins) flaming in brandy.

(Although brandy burns at a lower temperature than wood, we do not recommend this game!) Snap-dragon began with the children being carried into a darkened room by someone dressed as a ghost, and the thrills abounded.

The stories told on Christmas Eve around the table or at the roaring fireside were often goblin tales. Indeed, several of Dickens' later Christmas fables were ghost stories, which included cemetery settings and required someone with an evil spirit to have a seasonal change of heart. We know that even after Charles Dickens was married and a father, and thus the leading man in a household of his own, one game he directed required participants to make frightening faces in the eerie light of a burning bowl, harkening to unseen spirits.

The last drink on Christmas Eve was a hot spiced elderberry wine, thought to be sleep-inducing—as if such was needed.—A.R.

Christmas Eve Menu

Wassail Punch

Oyster Scollop
Chicken Pies
Carrots in their own Juice
A Mash of Potato and Turnip
Bread and Butter
Mincemeat Tarts

Gin Punch
Porter
Ale
Gunpowder Green Tea
Elderberry Wine, Hot and Spiced

WASSAIL

*F*or centuries, wassail punch was served in Britain from Christmas Eve to the Twelfth Night.

Wassail and other Christmas foods have been honored in poetry, a true sign of respect.

The "beane" in the verse below was a token representing the Lord of Mirth, hidden in the Christmas cake. In times past, the lucky soul who found the bean in his portion was named king of the day, and assumed power over all. The "plums" are raisins. The "lambs-wooll" refers to the froth on the heated ale in the wassail punch.

Now, now the mirth comes

With the cake full of plums,

Where beane's the king of the sport here . . .

Next crowne the bowle full

With gentle lambs-wooll;

Adde sugar, nutmeg and ginger,

With store of ale too;

And thus ye must doe

To make the wassaile a swinter [a winner].

"Twelfe Night" or "King and Queen" by Robert Herrick, 1591–1674

WASSAIL PUNCH

2 cups ale
1 cup sherry
1/4 cup sugar, or to taste
*Black pepper
*Ground nutmeg
*Ground cloves
*Ground cinnamon
*Ground ginger
1/4 to 1/3 cup bread crumbs
12 small baked apples

Roast the apples at 375°F until they crack open and the pulp comes spilling out, 30–40 minutes.

Heat ale and sherry in a saucepan.

Add sugar to taste.

Sprinkle in large pinches of spices, to taste.

Stir in breadcrumbs.

Add whole apples to the heated ale mixture.

Serve in a large basin or a punch bowl, with cups.

*Wassail must be flavored to taste. Begin with a little of each spice and add more gradually until it tastes good to you.

50

Oyster Scollop

ash them thoroughly clean with their own liquor, and then put them in your scollop shells; strew over them a few crumbs of bread. Lay a slice of butter on the first you put in, then more oysters, and bread, and butter, successively, till the shell is full. Put them into a Dutch oven to brown, and serve them up hot in the shells.

The Female Instructor or Young Woman's Friend and Companion
(London, 1837)

SCALLOPED OYSTERS

2 pints of fresh oysters, shelled
 (about 60), including liquid
1/2 tsp. ground mace or nutmeg
1 Tbsp. butter
1 Tbsp. flour
2-3 slices white bread
2-3 Tbsp. heavy cream

Separate oysters from their liquid and reserve the oysters. Place liquid in a medium saucepan with ground mace or nutmeg.

Mix butter and flour into a roux until smooth and add to oyster liquid. Bring mixture to a boil, stirring constantly, and then simmer for 3 to 4 minutes.

While pot is simmering, toast bread slices and then cut each toast diagonally into 4 triangles. Place triangles around the edge of a large, shallow bowl in which the oysters are to be served.

Add reserved oysters and heavy cream to hot, thickened oyster liquid. Shake pot and cook until quite hot. Do not boil, as the oysters will become hard. Pour into serving bowl and serve hot.

Serves 8 to 12.

CHICKEN PIE

This chicken pie descended from the standing pie, made from an inedible dough of flour, a good quantity of salt and boiling water. It was a tough dough erected into vertical walls on a flat base. The structure was filled and then covered with a flat slab. Known as a coffin, it was baked before diners scooped out the filling to eat.

By the eighteenth century the standing crust had been replaced by puff pastry or standard pastry. In Dickens' day, poultry pies were prepared without a pastry bottom, but the pie sides and top were delectable.

Fowls were expensive as their primary value lay in their eggs. But old hens and caponized roosters were available in summer, fall and early winter at markets. In the words of Eliza Acton (*The Best of Eliza Acton*, 1845), "Fowls are always in season when they can be procured sufficiently young to be tender. About February, they become dear and scarce; and small spring chickens are generally very expensive. As summer advances they decline in price."

The use of the term "fowl" suggests an older hen, possibly culled to reduce the size of the winter flock feeding on stored grain.

AN 1837 CHICKEN PIE

Season your chickens with pepper, salt, and mace. Put a piece of butter into each of them, and lay them in the dish with their breasts upwards. Lay a thin slice of bacon over them, which will give them an agreeable flavor. Then put in a pint of strong gravy, and make a good puff paste. Put on the lid, and bake in a moderately heated oven.

The Female Instructor or Young Woman's Companion (London, 1837)

A COMMON CHICKEN PIE

Prepare the fowls as for boiling, cut them down into joints, and season them with salt, white pepper, and nutmeg or pounded mace; arrange them neatly in a dish bordered with paste, lay amongst them three or four fresh eggs boiled hard, and cut in halves, pour in some cold water, put on a thick cover, pare the edge, and ornament it, make a hole in the centre, lay a roll of paste, or a few leaves around it, and bake the pie in a moderate oven from an hour to an hour and a half. The back and neck bones may be boiled down with a bit or two of lean ham, to make a little additional gravy, which can be poured into the pie after it is baked.

Eliza Acton, Modern Cookery for Private Families (London, 1845)

FRENCH CRUST FOR HOT OR COLD MEAT PIES

Sift flour, and break the butter, work them together with the fingers until they resemble crumbs of bread, then add a small teaspoonful of salt, and make them into a firm paste, with the yolks of eggs, well beaten with cold water.

Eliza Action, The Best of Eliza Acton (London, 1845), selected and edited by Elizabeth Ray (1968)

Pie Crust

2 cups flour
2/3 cup lard or butter or rendered chicken fat
1 tsp. salt
7-8 Tbsp. cold water

Place flour into mixing bowl and cut in lard, butter or chicken fat, leaving lumps of fat of uneven sizes. Add salt and mix.

Add cold water quickly, just barely forming a ball.

Cut in half to form two balls.

Roll out one ball into a circle a bit larger than the size of your pie pan, and place in the pan.

After you've added the filling, roll the second ball and place it over the chicken filling. Crimp the dough edges into a decorative raised rim.

More Gravy for Filling

Chicken neck and back bones to make 1 cup of broth or 1 cup of pre-made chicken broth
1/2 cup ham scraps
water
2 Tbsp. flour
1 Tbsp butter

For extra gravy, make a broth of back and neck chicken bones and ham scraps and simmer for 30 minutes. Strain and discard the bones.

Mix butter and flour to form a roux.

Add roux to the broth, cook for two minutes until thick and pour into baked pie.

The Chicken Pie

1 6-8 lb. roasting chicken
Salt to taste
Pepper to taste
Ground nutmeg to taste
1/2 lb. bacon, coarsely chopped
1 egg beaten
4 hard-boiled eggs, halved
1 cup chicken broth
2 Tbsp. flour
1 Tbsp. butter

Prepare a pie shell as described (above left) or if you'd rather not make your own pie crust, you can use a prepared pie shell or a pre-made puff pastry.

Line the sides of a 9" or 10" deep-dish pie tin with the unbaked crust.

Cut the chicken into serving pieces, bone in, and sprinkle with salt, pepper, and nutmeg to taste. Arrange in pie pan. Cover chicken with chopped bacon.

Add halved hard-cooked eggs.

Stir flour and butter into a roux in a small saucepan and add the broth to it, stirring well.

Heat the mixture until thickened and add to the pie filling.

Cover with a top pastry, crimping the edges together and cutting a small hole in the center for a steam vent. Using pastry scraps, edge the vent with decorations of stems and leaves. Brush with beaten egg to make a golden glaze. Bake at 375°F for 1 1/2 hours or until crust is golden.

Remove from oven.

Pie may be eaten warm or cold.

Serves 8-10

MINCEMEAT PIE

*M*incemeat pie is one of the icons of Christmas feasting, so much so that it would not be uncommon for a family to have enjoyed it both on Christmas Eve and at their big holiday dinner the next day. The family in this Dickens story ordered their pies from a local bakery.

Mince pie is a descendant of a Medieval concoction of meats, fruit (both fresh and dried) sugar, spices and brandy. The alcohol, sugar and spices preserved the mixture as it aged in a stoneware crock stored in a cool root cellar for as long as two or three months. Such a crock would have been sealed with tied-on leather.

Commercial modern mincemeat pies are meatless, since meat becomes overcooked in the bottling process, which also causes the pie filling to lose flavor and texture.

It pays to make your own.

MINCE MEAT

*T*ake a pound of beef, a pound of apples, two pounds of [beef] suet, two pounds of sugar, two pounds of currants, one pound of candied lemon, or orange peel, a quarter of a pound of [candied] citron an ounce of fine spices, mixed together; half an ounce of salt, and six rinds of lemons shred fine. Let the whole of these ingredients be well mixed, adding brandy and wine sufficient to your palate.

The Female Instructor or Young Woman's Companion (London, 1837)

MINCEMEAT PIE

1 lb. ground beef
1 lb. apples, peeled, cored and chopped
2 lbs. beef kidney suet (available in specialty butcher shops), chopped
2 lbs. sugar
2 lbs. dried currants
1 lb. candied lemon or orange rind, cut small
1/4 lb. candied citron*
2 Tbsp. combined ground cinnamon, nutmeg, cloves
1 Tbsp. salt
Zest of 6 lemons, finely shredded
Brandy
Sweet red wine

Mix all of these ingredients in a large confectionery pan or enameled iron pot, with enough brandy and sweet wine to cover.

Bring to a boil and simmer for 1/2 hour.

Pack into jars and refrigerate until used. (The mixture benefits from 1 to 2 months of aging, and lasts for 2 years when refrigerated.)

*Citron is a member of the citrus family, and looks like a large lemon. Originally from the Middle East, it is skin and rind, with very little pulp. Genuine candied citron is far more attractive and pleasing to the taste than the small cubes of "candied citron," highly preserved with chemicals, found in many stores. Citron appears in some specialty food catalogs; as Christmas approaches, some specialty Italian markets stock it.

54

To candy lemon or orange peel and citron:

Cut rinds into thin slivers, weigh them and combine with an equal weight of sugar.

Refrigerate overnight.

The next day, the rinds will appear bathed in their own juices. Place the sugared rinds and their juice into a large jelly pan (a deep casserole or soup pot of copper, brass or enamel).

If necessary, add water to reach a bit below the top of the fruit. Bring to a boil and simmer for 1½ to 2 hours, or until the rinds become translucent.

Remove from syrup and place on a platter of dry sugar, tossing to cover evenly. These candied peels last almost indefinitely; it pays to make up more than needed and reserve in refrigerator for future projects.

Or you may purchase candied peels:

However, be careful when choosing them. Select whole candied citrons as described (in asterisked note on previous page). In a good candy shop you may find high-quality candied lemon or orange rinds.

Assembling Mincemeat Pie

Make standard pie dough (see Pie Crust recipe on page 53) or use a pre-prepared shell.

Roll out one crust and place in 8" pie pan.

Fill shell with aged mincemeat mixture.

Cover with remaining crust, or cut dough into strips and weave a lattice top.

Bake at 425°F for 30 minutes or until top crust is brown, and filling is hot.

Mulled Elderberry Wine

5 ounces water
1 tsp. ground ginger
1/2 tsp. ground cinnamon
6 Tbsp. sugar
1 or 2 strips orange rind
1 pint elderberry wine

Combine all the ingredients but the wine.

Heat until mixture makes a thin syrup, but do not let it boil.

Adjust spices to your liking.

Add wine and keep warm but below boiling point.

Serves 12

There was no single traditional Christmas Dinner menu in the 1830s or 1840s. The turkey was usual but not irreplaceable; other poultry or various roasted meats might have been served in its stead.

Soups, fish, meats and side dishes were almost certainly a matter of an individual family's preference and influenced by market availability and budget. It is fair to say, though, that a mincemeat pie and a Christmas pudding were essential sweets of the feast.

We know that following Charles Dickens' marriage, his wife saw to it that the concluding course of festive dinners included Green Salad and Toasted Cheese because he loved it. Toasted Cheese is a savory which has also been called Cheese Rarebit, Cheese Rabbit, Welsh Rabbit or English Rabbit. The dish consists of a good aged Cheddar or Stilton melted with wine and butter, served over toast.

By the time Dickens wrote "A Christmas Carol" in 1843, the ideal British Christmas dinner had grown enormous, thanks, in part, to his own efforts. In that later work, Dickens depicts "The Spirit of Christmas Present" sitting on a throne of "turkeys, geese, game, poultry, brawn (a roasted leg of boar), great joints of meat, suckling-pigs, long wreaths of sausages, mince-pies, plum-puddings, barrels of oysters, red-hot chestnuts, cherry-cheeked apples, juicy oranges, luscious pears, immense twelfth-night cakes, and seething bowls of punch, that made the chamber dim with their delicious steam."

57

Charles and Catherine Dickens did not quite manage to furnish their Christmas table with such proliferation, but they surely did their best.

Several foods on the Christmas Dinner menu that follows are mentioned in his first Christmas story or evidenced in the manuscript on cookery prepared by Catherine Hogarth Dickens. The menu here is for a meal that a family such as the one in "A Christmas Dinner" would have enjoyed, except for its Christmas Cake, which became popular a few years later.

For one side dish, I've chosen a molded Kalecannon (a Scottish vegetable pudding), whose stripes give it an especially appealing holiday aspect. It's fanciful to think Charles and Catherine might have together layered this dish when their marriage was new (years later, and after ten children, they separated).

It's more likely that Charles only made the brandy punch. Brandy then was for the men only.

You do not need this book to tell you how to make roast meats or a green salad. But you might want to model your vinaigrette on what Catherine Dickens called a "Spanish Salad Dressing." She made her dressing with a heavy proportion of Spanish olive oil, just a bit of vinegar, and seasoned it with salt, pepper and a mixture of sweet herbs (marjoram, parsley, sage, thyme, rosemary, etc.) chopped fine. You may, of course, use a good olive oil from elsewhere and adjust the oil and vinegar proportions to your taste.

You're also much more likely to buy pickled mushrooms than to put fresh mushrooms in vinegar brine in late summer as Catherine did, so there is no call for such a recipe.

A few more notes on the desserts: the main reason to have a Lemon Jelly (gelatin or Jello™) is for the color and to show off the results of using an ornate bell-shaped mold, or one in the outlines of a fir tree, in which case you might want to make the flavor lime and add bright

fruit bits for ornaments. If you're a purist, though, you'll recall that the Christmas tree was a German import that did not claim a place in English homes until after the time of this story, and so is not mentioned in it.

The Christmas Pudding is the dessert most worth your energies. But the Christmas Cake, also a fruitcake, would be favored by marzipan lovers and is beloved by many children. Certainly, a proper Christmas dinner in 1835 had several sweets. However, you can, as grandmamma did, order some of them from your best local bakery.

The wines enjoyed during Christmas dinner would have included Champagne, Madeira and port, as well as Negus. Negus was a hot wine made with sherry or port; to prepare Negus, water is boiled before the wine and spices are added, while in mulled wine you warm the entire spiced, sweetened drink.

Purl, the most popular of ale drinks, would also have been offered from the sideboard. Purl originated during the Medieval years as a mixture of bitter herbs steeped in ale for many months and used for medicinal purposes. By the early 1800s, it had become a mixture of hot ale, gin, sugar and spices, and was enjoyed as a libation. The more everyday Burton Ale would also have been on hand. This ale was named for the site on the Trent River, Burton-on-Trent, where it was brewed using the river water. Today, any dark ale will do.

If you follow the menu and the offered recipes, you're all but guaranteed a Christmas meal every bit as splendid as the one enjoyed in "A Christmas Dinner." Of course, to replicate authentically the Dickens' experience, you'll have to sing for your supper—not before the meal, but afterwards, as you sit around the table with a full belly.—A.R.

Christmas Dinner Menu

Brandy Punch

Cock-a-Leekie Soup
Cod with Oyster Sauce
Turkey, Stuffed with Forcemeat, and Roasted
Lamb with Celery Sauce
Kalecannon, Molded in Stripes
Baked Beet Root, Pickled
Stewed Chestnuts Pickled Mushrooms
Rolls and Butter

Lemon Jellies
Fruit, Nuts,
Candies
Cheese Rarebit
Green Salad

Christmas Pudding
Christmas Cake
Mince Pies

Wine
Beer
Ale

PUNCH

Brandy punch was the drink of gentlemen, and gin punch that of common folk, but either drink marked an important occasion.

Gentlemen in a club or paneled office might raise a glass of brandy punch in celebration.

In an upper-class home, ladies and gentlemen would separate before a festive dinner so that male guests could join their host in his study. There he'd mix a spectacular drink of spirits, almost always including brandy (sometimes joined by rum), lemon juice, sugar and water. The punch in such a setting was served in cups matching the sparkling silver or cut-glass punch bowl they surrounded.

Meanwhile, the ladies in the parlor partook of fruit juices.

GIN PUNCH

A gin punch such as the one enjoyed "below stairs" was the same sort of concoction, with the gin substituting for the more elegant spirits, probably mixed with less lemon and sugar. It was mixed and served in whatever might be handy.

CHARLES DICKENS' OWN PUNCH

Juice and thinly peeled rind of 3 lemons; 2 good handfuls of lump sugar; 1 quart boiling water; 1 pt. old rum; 1 or 2 large wineglasses brandy.

The Dickensian I, (18 January, 1847)

Brandy Punch

3 lemons
1 cup sugar
1 quart boiling water
1 pint of aged rum
6 – 7 ounces brandy
A large chunk of ice

Thinly peel off zest of the lemons and squeeze out their juice. Place juice and zest in punch bowl.

Add boiling water, sugar, rum and brandy, and stir for a minute.

Add a large chunk of ice to the bowl.

Serve well-chilled by the dipper-full.

61

COCK-A-LEEKIE SOUP

Cock-a-Leekie was one of Catherine Dickens' favorite dishes. It seems to have originated in the Medieval era in her native city of Edinburgh, Scotland. The soup's curious name is thought to come from the practice of sending the loser of a cock fight to the soup pot, along with leeks and prunes. The soup, a holiday institution, is sometimes called "Christmas Cock-a-Leekie." Among its fans were the novelist Sir Walter Scott, the chef Alexis Soyer, and Meg Dods, author of *The Cook and Housewife's Manual* (London, 1826).

These days, the soup is sometimes enriched with barley or potato. At the time of Dickens, a soup like this was served in two parts: first the broth, followed by the chicken from the stockpot. On occasion, Cock-a-Leekie is still presented that way. Below is Catherine Dickens' own recipe for this fine soup.

Make a stock of six or eight pounds of beef, seasoned as for brown soup, and when cold skim off the fat. Wash well a bunch and a half of leeks, and cut them in pieces of an inch length. Put on the stock with two-thirds of the leeks, and a good sized fowl, and boil for an hour. Then take out the fowl, skin it, and cut it into small pieces, return it to the soup along with the other third of the leeks, and boil all up for another hour. If prunes be liked, throw in a quarter of a pound half an hour before serving. Some cooks thicken this soup with fine oatmeal, but if the leeks be tender, they boil away sufficiently to make this soup of a proper thickness and consistency without this addition.

Lady Maria Clutterbuck's [Catherine Dickens], What Shall We Have For Dinner?, London, 1852, recorded in Susan M. Rossi-Wilcox's Dinner For Dickens (Totnes, 2005)

62

5-6 lbs. beef or veal (soup cuts)
Water to cover
5-6 lb. chicken (stewing hen)
11/2 bunches of leeks
1/4 lb. prunes
Salt and pepper to taste

Place beef or veal into a large soup pot and add water enough to cover.

Bring to a boil and simmer for 4 hours.

Place in a container, cover and refrigerate overnight.

The next day, skim off the hardened fat that has risen to the top. Return the jelled broth to the pot.

Add the fowl and 1 bunch of leeks (reserving the other 1/2 bunch). Bring to a boil and simmer for 1 hour.

Remove fowl, skin it, and pull the meat off the bone. Return the meat to the pot.

Add the remaining half bunch of leeks and simmer for 1/2 hour.

Add prunes and continue simmering for another 1/2 hour.

Add salt and pepper to taste, and serve hot.

Serves 8 to 12

COD WITH OYSTER SAUCE

The portmanteaus and carpet-bags have been stowed away, and Mr. Weller and the guard are endeavouring to insinuate into the fore-boot a huge cod-fish several sizes too large for it—which is snugly packed up, in a long brown basket, with a layer of straw over the top, and which has been left to the last, in order that he may repose in safety on the half-dozen barrels of real native oysters, all the property of Mr. Pickwick, which have been arranged in regular order at the bottom of the receptacle . . . The guard and Mr. Weller disappear for five minutes: most probably to get the hot brandy and water, for they smell very strongly of it.

– Charles Dickens, *The Pickwick Papers, Ch. XXVII*

COD AND OYSTERS

Such a large cod would probably have been divided into several portions to be cooked, the head and shoulders being gently poached, then sent to the table on a napkin, garnished with lemon and horseradish, to be served with oyster sauce and plain melted butter.

Brenda Marshall, *The Dickens Cookbook,* Toronto, 1980

Codfish was widely available year round, caught in the cold waters off the Newfoundland Banks and hauled back to England. Cod is a mild fish, delicate and sweet in flavor. Some individual fish weighed in at fifteen or twenty pounds. The heads and collars were prized–the cheeks were especially favored–but for large dinner parties the fillets were choice.

As for oysters, in the nineteenth century large numbers of them could be pulled out of the Thames River, keeping them inexpensive enough to be indulged in by poor and rich alike.

Oysters were not only seen in sauces, they were also cooked up in pies and stews. Of course, they were also eaten raw.

Cod with Oyster Sauce was a dish that Mrs. Dickens often served. Her recipe called for poaching the cod fillet, probably in the fish kettle that was listed in the "Estate Inventory" made in 1844.

The Christmas Eve recipe for Scalloped Oysters, a cream stew of oysters (p.51) could, perhaps with fewer oysters per person, be used as a sauce for cod.

The Modern Cook

Cod may be poached or planked: Rub a fillet with melted butter before tying it with butcher's cord onto a damp wooden board that can stand against a fireplace wall to broil. The plank needs to be turned upside down a bit more than half-way during the cooking so the fish cooks evenly. This only takes a few minutes. Mrs. Dickens broiled her fish that way, and if you are lucky enough to have a fireplace you can broil this way, too.

TURKEY, STUFFED WITH FORCEMEAT, AND ROASTED

*I*n the early 1800s, several breeds of turkey were being raised and sold in England. After he was married, Charles and his wife both sent and received turkeys as gifts. We know that Catherine Dickens roasted the young birds but boiled the old ones.

ROASTING TURKIES

*W*hen your turkey is properly trussed for dressing, stuff it with the following ingredients: Take four ounces of butter, or chopped suet, some grated bread, a little lemon-peel, parsley and sweet herbs chopped together, pepper, salt, and nutmeg, a little cream, and the yolks of two or three eggs: work these all well together, and fill the craw with it. Let your fire be very brisk, and when you put it down, paper the breast, and let it continue on till near done; then take it off, dredge it with flour, and keep basting it till it is done . . . A middle-sized turkey will take more than an hour, a smaller one, three quarters of an hour.

The Female Instructor or Young Woman's Companion (London, 1837)

Roast Turkey with forcemeat stuffing

1 turkey of 8-10 lb.
1 Tbsp. fresh parsley
1 Tbsp. Sweet, mixed herbs (marjoram, chives, rosemary, tarragon) of your choice
1/2 tsp. ground nutmeg
1/2 cup softened butter
1/2 cup unflavored bread crumbs
1/2 tsp. grated lemon peel
Pepper and salt to taste
3 Tbsp. heavy cream
3 egg yolks
6 ounces pork sausage removed from casing
Flour for dredging
Butter for basting
Parchment paper

Preheat oven to 375-400° F.

Chop the sweet herbs.

Mix butter, breadcrumbs, lemon peel, parsley, sweet herbs, nutmeg, salt, pepper, cream, egg yolks and sausage meat. Blend well.

Press some of this mixture into the turkey body cavity for stuffing, and reserve the rest of the meat to mold into small balls to be roasted alongside the turkey. Refrigerate the reserved meat mixture.

Wrap parchment paper tightly around the turkey breasts. (Pushing the paper under each leg helps keep it down.)
Tie legs and wings down.

After an hour, or an hour and a half for a larger turkey, remove the parchment paper from the turkey and discard. Dredge the bird with flour. (You can put the flour on a cloth and daub it on the bird.) Baste the bird with melted butter. Add the forcemeat balls to the roasting pan.
Baste the bird every ten minutes or so for the next half hour or until the turkey skin is brown and crisp and the turkey is done.

Serves 10-12

Lamb (or mutton) with Celery Sauce

\mathcal{L}amb and mutton were highly thought of in the 19th century. "House Lamb" (raised on hay) was fashionable from Christmas on to Lady Day in late March (a date once associated with the Annunciation) opposed to "Grass Lamb," which was in season from Easter to the late-September feast of Michaelmas. Catherine Dickens enjoyed serving roasted mutton or lamb, dressed with a celery sauce.

Lamb Roasted the Old Way

\mathcal{L}amb is especially fine when roasted on the hearth, as people would have cooked it in 1835. If you'd like to try this, you'll need a fireplace and a spit (no motor) and a tin reflecting oven. Insert the spit through the roast, and then place skewers through the meat and each spit hole. Truss the meat to hold it together.

Set the spit in a tin reflecting oven in front of the fire and roast for 2 to 2 1/2 hours, turning the spit every 15 minutes until it reaches the degree of doneness you like.

Or you can put the meat on spit dogs driven by a clock jack (a mechanical rotisserie-like gadget), for about the same amount of time. To judge doneness, pierce the meat with a thin knife: the juices of a well-done roast will run clear; those of a medium-rare roast will be red.

Celery Sauce

\mathcal{C}ut the white part of the celery into pieces about an inch in length, and boil it up in some water till it is tender. Then take half a pint of veal broth and a blade of mace, and thicken it with a little flour and butter; add half a pint of cream, and boil them gently together. Put in your celery, and when it boils pour them into your boats.

The Female Instructor or Young Woman's Companion (London, 1837)

The Modern Cook

Roast Lamb

An 8-10 lb. leg of lamb will roast at 325°F in a modern oven. It will take 14 to 16 minutes per pound for medium rare or until the meat reaches 140 to 145° F. Roast on a rack.

Celery Sauce

2 cups sliced celery
Water
1 cup veal or chicken broth
1/4 tsp. ground nutmeg
2 Tbsp. flour
1 Tbsp. butter
1 cup heavy cream
Salt and pepper to taste

Cut the stalks of celery into 1 inch lengths and place in small saucepan.

Add water to cover, bring to a boil, and simmer until tender. Drain and reserve.

Place veal or chicken broth in saucepan; add nutmeg.

Make a roux of flour and butter: press and roll them together until well blended. Add to broth mixture and bring to a boil whisking constantly. Simmer until thickened.

Add cream, salt, and pepper and simmer gently for 2 – 3 minutes.

Add celery, and when the mixture is hot, place in gravy boats and serve.

Serves 8 to 10

BAKED BEET ROOT, PICKLED

Beets were plentiful and delicious in wintertime Britain, and certain to be included in festive meals. An 1838 English cookbook mentions them in the section entitled, "Work in December."

Its instruction: "Take up the red-rooted beets on a dry day, and let them be placed in sand & under cover, for use in case of hard frost."

Beats are easily baked or boiled; the boiled version loses color and flavor to the water, while the baked version concentrates the sugars and makes the flavor more intense.

To Bake Beet Root

Beet root if slowly and carefully baked until it is tender quite through, is very rich and sweet in flavour, although less bright in colour than when it is boiled: it is also, we believe, remarkably nutritious and wholesome. Wash and wipe it very dry, but neither cut nor break any part of it; then lay it into a coarse earthen dish, and bake it in a gentle oven for four or five hours: it will sometimes require even a longer time than this. Pare it quickly if it be served hot; but leave it to cool first, when it is to be sent to table cold.

Eliza Acton. *The Best of Eliza Acton* (London, 1845), selected and edited by Elizabeth Ray (1968)

BOILED BEET ROOTS

Boil them till tender, take off the skins, cut them in slices, gimp them in the shape of wheels, or what form you please, and put them into a jar. Take as much vinegar as will cover them, and boil it with mace, a race of ginger sliced, and a few pieces of horse-radish. Pour it on hot, and tie them down close.

A Lady, The New London Cookery, Adapted to the Use of Private Families. 9th Edition (London 1838)

68

The Modern Cook

Pickled Beets

2 bunches medium-sized beets (2 to 3 pounds)
2 to 2 1/2 cups vinegar, or enough to cover cooked, sliced beets
2 Tbsp. sugar
Juice of 1/2 lemon
1 tsp. ground ginger
Salt and pepper to taste
1 inch of a fresh horseradish bulb, washed and cut into thin slices
A few capsicums (hot chili peppers) or 1/4 tsp. cayenne

Preheat oven to 350°F.

Cut the beets from the stems, allowing 1 inch of stem to remain on the root.

Bake in 350°F oven for 1 to 1 1/2 hours until beets test tender when pierced with a knife.

Allow beets to cool, then remove remaining stems, and peel them.

Slice each beet into 1/2-inch thick discs. Place sliced beets in a jar.

Combine remaining pickling ingredients, warm slightly in a saucepan, and pour over beet slices.

Cover, let sit in refrigerator for a day or two before serving.

Serves 8

KALECANNON

Kalecannon, also called colcannon, is a traditional Celtic cabbage and potato dish, sometimes enriched with onions, turnips and carrots. It was a special Hallowe'en dish, but also notable at Christmas; one popular early version was a dish of mashed boiled cabbage and potato, dressed with melted butter and sautéed onions. Catherine Dickens appears to have learned it in her native Scotland, and gussied it up. She replaced the cabbage with young greens, in this case

spinach, arranged the vegetables in stripes---no doubt to dramatize the color contrasts---in a tin melon mold. In Catherine Dickens' day, shaped molds were commonly used to create decorative forms. A mold was buttered, and perhaps sprinkled with fine bread crumbs, to facilitate careful removal of the food shaped within it.

That's still a good idea. If you have an antique tin mold, you will want to use it covered—either with its original tin cover or a tightly-tied aluminum foil wrap.

KALECANNON

℔oil three or four carrots tender, some nice young greens, a few turnips, a few potatoes; cut off the outsides of the carrots and chop them up very fine, also chop the greens, mash the turnips and potatoes, then place it in a melon shape to form the stripes of colours, filling up the interior of the mould with all the vegetables chopped up together with pepper and salt. Butter the mould, and boil half-an-hour.

Lady Maria Clutterbuck [Catherine Dickens], *What Shall We Have For Dinner?*, London, 1852, recorded in Susan M. Rossi-Wilcox's *Dinner For Dickens* (Totnes, 2005)

Kalecannon

4 large carrots, peeled
1 lb. fresh spinach
1 lb. purple turnips
1 1/2 lb. baking potatoes
2 Tbsp. melted butter
Pepper
Salt

In separate pots, boil the carrots, spinach, turnips and baking potatoes.

When the carrots are tender, cut off the outside of each carrot into 3 or 4 vertical strips, saving the inside for chopping. Reserve.

When the spinach is tender, drain and chop fine. Reserve.

When the turnips and potatoes are tender, peel them and mash them together.

Butter a large melon mold, and place the strips of carrot, chopped spinach and mashed potato into stripes, alternating the colors, into the bands of the mold.

Mash the remaining vegetables together, add salt and pepper, and pack into the center of the mold.

Cover with buttered and bread-crumbed lid, and steam in a covered soup pot for 30 to 40 minutes. Remove, cool slightly, and un-mold onto a platter.

Serves 8-10

STEWED CHESTNUTS

*C*hestnut trees, which had flourished for some time in Spain and France, were planted in England during the Elizabethan period but their nuts were not widely enjoyed for a long time. Two centuries later, serving chestnuts was still a novelty, but stewed chestnuts, as a holiday side dish, became fashionable in the first half of the nineteenth century.

ELIZA ACTON'S STEWED CHESTNUTS

*S*trip the outer rind from forty or fifty sound Spanish chestnuts, throw them into a large saucepan of hot water, and bring it to the point of boiling; when the second skin parts from them easily, lift them out and throw them into plenty of cold water; peel, and wipe them dry; then put them into a stew-pan or bright saucepan, with as much highly-flavoured cold beef or veal gravy [broth] as will nearly cover them, and stew them very gently from three-quarters of an hour to a full hour; they should be quite tender, but unbroken. Add salt, cayenne, and thickening if required, and serve the chestnuts in their gravy. We have found it an improvement to have them floured and lightly browned in a little good butter before they are stewed, and also to add some thin strips of fresh lemon-rind to the gravy.

Eliza Acton. *The Best of Eliza Acton* (London, 1845), selected and edited by Elizabeth Ray (1968)

Stewed Chestnuts

40 to 50 chestnuts
11/2 cups (or more) of meat gravy or strong broth
3–4 strips of fresh lemon rind
Flour for dusting chestnuts
2-3 Tbsp. butter
Salt to taste
Cayenne to taste

Using a goose-necked paring knife or a chestnut knife, score the outer rind of chestnuts with an "X." Boil for 10 to 15 minutes, or until the rind is softened.

Remove nuts from the water, and peel off the rind. Put the nuts back in the pot of hot water and allow them to soak until the inner skin separates from the nut. Remove the skin.

Dry nut cores, and dust them with flour.

Fry the nut meats in butter until lightly browned.

Now place the chestnuts with the meat gravy or your thick beef broth in a saucepan. Add lemon strips. Stew very gently for 3/4 of an hour to one hour until nuts are soft. Do not break them.

Add salt and cayenne to taste.

Serve hot with the now nut-flavored meat sauce.

Serves 8 to 12

CHRISTMAS PUDDING

The Christmas or Plum Pudding, which was an English treat by the Renaissance period, is a sweet assemblage of a variety of dried fruits (called plums), fat, flour or bread crumbs, spice and liquor. As still prepared in the early 1800s, it was a thick mixture that needed much stirring, a difficult and lengthy process that benefited from many hands. Dickens indicates in his story that the entire family ventures into the kitchen on Christmas Eve to "stir the pudding."

Long before Dickens, puddings were boiled in pudding bags, or large squares of flannel that had been dipped into boiling water and then dredged on both sides with considerable amounts of flour. The dredged cloth was spread over a bowl and the stirred pudding mix was poured into it.

The cook then drew up and tied together the four corners of the cloth and other loose edges, allowing a bit of air in the top so the pudding could swell. Next, she suspended the filled pudding bag from the handle of a large wooden spoon that bridged the top of a large pot of boiling water. The bag was hung so it would not touch the sides or bottom of the pot but was low enough to be submerged in the boiling water. The pudding was kept boiling gently for several hours, with boiling water added from time to time so the pudding bag remained immersed.

By Dickens' day, some cooks used tin melon molds in place of pudding bags. Such a mold, ridged and shaped like half a melon, with a tight-fitting cap, can be purchased today. A molded pudding is steamed in a large covered pot rather than boiled.

When a pudding was firm throughout, it was removed to a bowl and allowed to cool a bit. A Christmas pudding, which might be prepared hours or even weeks in advance, was drenched in additional brandy. If it was aged, it might again have been boiled before serving.

The Christmas Pudding, decorated with a sprig of holly and set on a platter, was served at the end of Christmas dinner. Flaming in the brandy, it was carried to the darkened dining room. The flaming ball, reminiscent of the sun, was an icon of the season, commemorating the return of lengthening days and the promise of a fertile season to come.

These days, Christmas Pudding is sometimes found in baked form, a simpler procedure. However, if one is going to go to the bother with all the measuring and mixing (not to mention finding beef kidney suet* and genuine citron), one might as well do the boiling or steaming, too. A traditional Christmas Pudding makes a gorgeous appearance.

*Beef kidney suet is the layer of fat around the kidney of the steer, and it offers a special flavor to the pudding. It is also free of membranes, and easy to chop. It may be ordered at specialty butcher shops.

Eliza Acton's Christmas Pudding

To three ounces of flour, and the same weight of fine, lightly-grated bread-crumbs, add six of beef kidney-suet, chopped small, six of raisins weighed after they are stoned, six of well-cleaned currants, four ounces of minced apples, five of sugar, two of candied orange rind, half a teaspoonful of nutmeg mixed with pounded mace, a very little salt, a small glass of brandy, and three whole eggs. Mix and beat these ingredients well together, tie them tightly in a thickly-floured cloth, and boil them for three hours and a half. We can recommend this as a remarkably light small rich pudding: it may be served with German wine, or punch sauce.*

Eliza Acton. *The Best of Eliza Acton* (London, 1845), selected and edited by Elizabeth Ray (1968)

*In the Dickens story, the children are busy all day stoning "plums," but back then "plums" could refer to any dried fruit, i.e. raisins, which then contained pits. Stoning the raisins meant pitting them.

Christmas Pudding

1/2 cup flour
1/2 cup lightly grated bread crumbs
3/4 cup beef kidney suet, chopped fine
3/4 cup raisins
3/4 cup dried currants
1 large apple, peeled, cored, and diced
1 cup + 2 Tbsp. sugar
4 Tbsp. candied orange rind or candied citron
1/2 tsp. ground nutmeg
3 ounces brandy
3 eggs
Salt to taste
Additional flour to dredge the pudding bag, if used
6 ounces brandy for flaming

Mix all ingredients thoroughly together.

Boil a large pot of water. Dip the pudding bag into it, flour thoroughly, and place in a large bowl. Pour in the mixture, tie up securely, leaving an air space to allow for swelling, and a length of cord to hang it suspended into the pot. (A large wooden spoon that bridges the rim of the pot holds it nicely.) Fill in the small opening left at the knot with flour and water paste, to keep the pudding dry. Boil for 31/2 hours, replenishing with additional boiling water to keep it immersed.

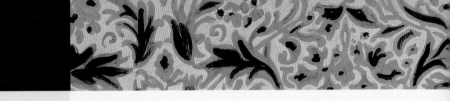

Steamed Pudding, cont'd.

OR: Butter an 8-inch melon mold, add the pudding mixture, and cover with the buttered lid. Place on a rack in a large covered pot, and steam over 2 inches of water for 3 1/2 hours. Cool a bit before removing from mold.

You'll want to place the pudding in a ceramic bowl and set that on a large metal tray, for safety's sake, before proceeding with the final steps.

Pour 2 ounces of brandy into the pudding.

Heat additional brandy, pour it over the pudding and ignite with a long match just before presentation in a darkened room.

Serve with wine sauce.

Serves 12-16

WINE SAUCE FOR SWEET PUDDINGS

Boil gently together for 10-15 minutes the very thin rind of half a small lemon, about an ounce and a half of sugar, and a wineglassful of water. Take out the lemon-peel and stir into the sauce until it has boiled for one minute, an ounce of butter smoothly mixed with a large half-teaspoonful of flour; add a wineglassful and a half of sherry or Madeira or other good white wine, and when quite hot serve the sauce without delay. Port wine sauce is made in the same way with the addition of some grated nutmeg and a little more sugar. Orange-rind and juice may be used for it instead of lemon.

Eliza Acton. *The Best of Eiza Acton*
(London, 1845),
selected and edited by Elizabeth Ray (1968)

73

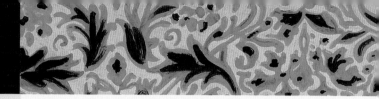

German Wine Sauce

1 small lemon
4 Tbsp. sugar
1/2 tsp. grated nutmeg
6 ounces water
4 Tbsp. butter
1 tsp. flour
1 cup Port wine

Squeeze lemon and reserve juice.

Boil together the rind of the lemon, sugar, nutmeg and water for 10 minutes.

Remove rind and discard.

Add lemon juice, butter and flour, rolled together in a roux and simmer until thickened, stirring constantly.

Add wine and serve immediately.

CHRISTMAS CAKE

also called Plum Cake or Twelfth Cake

This rich fruitcake, topped with a sheet of marzipan, is another dried fruit and spice combination, but this time it's baked and, when cooled, draped with marzipan. The roots of the fruitcake are in the boiled pudding of the Middle Ages, whose most prominent survivor is the classic Christmas Pudding just considered here.

The steamed concoction was converted to a baked cake in the kitchens, fitted out with capacious ovens, of affluent Victorian homes, or in neighborhood bakeries.

The cake came to be particularly identified with Twelfth Night, which on January 5 capped a dozen days of Christmas celebrations. In many churches, Twelfth Night symbolized the evening the Three Kings bestowed their gifts upon the Christ child. Queen Victoria, disturbed by the ribaldry into which Twelfth Night celebrations had descended, banned its observance. Then this elaborately decorated cake moved to Christmas Day festivities. The Christmas Cake mentioned in "A Christmas Dinner" may not have had a topping as fanciful as some Victorian concoctions, but marzipan-topped fruitcake was beloved.

Most cake forms then used by home bakers were round, thin iron hoops, bottomless forms with sides 2" to 4" high, and available in a variety of diameters. A hoop was greased, lined with several thicknesses of parchment paper and greased again, then set onto a baking sheet before being filled with the cake mixture and placed in an oven heated by a roaring fire.

Twelfth Cakes

Make a cavity in the middle of six pounds of flour, set a sponge with a gill and a half of yeast and a little warm milk; put round it a pound of fresh butter in small lumps, a pound and a quarter of sugar sifted, four pounds and a half of currants, half an ounce of sifted cinnamon, a quarter of an ounce of pounded cloves, mace, and nutmeg mixed, sliced candied orange, lemon-peel, and citron. When risen, mix all together with a little warm milk; have the hoops well papered and buttered, fill and bake them. When nearly cold, ice them over.

A Lady, The New London Cookery, Adapted to the Use of Private Families. 9th Edition (London, 1838)

To make March-pane [Marzipan]

Take Almonds, scald them, then put them into cold Water, drain them, wipe them, then pownd them in a Marble Mortar, moisten them frequently with the white of an egg to keep them from oiling. In the mean time take half the Weight of your Almond-paste, in clarify'd Sugar, boil it 'till it becomes feathered, then put in your Almonds by Handfuls, stir it well with a spatula, that it do not stick to the Pan. Pass the back of your Hand over it, and if it stick not to it, it is enough.

John Nott, *Cook's Dictionary* (London, 1726)

A Fine Iceing for Cakes

Beat up the whites of five eggs to a froth, and put to them a pound of double-refined sugar powdered and sifted, and three spoonsful of orange-flower water, or lemon-juice. Keep beating it all the time the cake is in the oven; and the moment it comes out, ice over the top with a spoon. Some put a grain of ambergris into the iceing, but that is too powerful for many palates.

A Lady, The New London Cooke Adapted to the Use of Private Families, 9th Edition, (London, 1838)

Christmas Cake

5 cups un-sifted flour
1 package yeast
1/4 cup warmed water
1 stick butter, softened
1/4 cup sugar
1/2 tsp. ground cinnamon
1/4 tsp ground nutmeg
1/2 tsp. salt
3–4 cups warmed milk
1 cup dried currants
1/2 cup candied orange rind
1/2 cup candied lemon rind
1/2 cup candied citron
3–4 Tbsp. apricot jam
2 7-ounce packages marzipan

Place flour in a large bowl, shaping a large hole in the middle.

Combine yeast and warm water and stir until dissolved; add to flour.

Break softened butter into small lumps and add to mixture.

Add sugar, cinnamon, nutmeg, and salt, and mix the contents of bowl.

Add milk gradually, kneading the mixture in the bowl until it becomes a sticky dough.

Add currants, orange rind, lemon rind and citron.

Continue kneading, adding flour as needed until the dough becomes elastic.

Cover the bowl, set in a warm place (about 80° F.) and allow dough to rise until double in size.

Without punching down the dough, carefully transfer to paper-lined, buttered 9" spring form (a pan with sides that open).

Preheat oven to 325° F. Place dough in pan on stovetop while the oven is heating. Let the dough continue to rise there until your oven is the right temperature.

Set the cake into the heated oven and bake 1 to $1\frac{1}{4}$ hours or until it tests done. Test by inserting a cake tester or straw into the cake. If it comes out clean, the cake is ready to leave the oven. Another sign that the cake is finished is that it comes away easily from the sides of the pan.

Allow the cake to cool, cover it with apricot jam and then a sheet of marzipan. Ice and decorate.

Marzipan Icing

Marzipan may be purchased in supermarkets or candy-making shops. Purchase and combine two 6-ounce packages of marzipan, then briefly knead it to shape a ball, and roll out to about 1/4 inch thickness.

Make your own marzipan

12 ounces finely ground almonds
6 ounces fine sugar
1 egg
2 extra egg yolks
Scant 1/2 tsp. almond extract (made from bitter almonds)

In a bowl, mix ground almonds and fine sugar, and reserve.

In another bowl, whip up egg, egg yolks and almond flavoring until thick and lemon colored.

Add egg mixture to mixture of ground almonds and sugar, then knead into a firm ball.

Roll it out to 1/4 inch thickness.

Icing

2 egg whites
1 1/2 cups sugar
1/4 tsp. cream of tartar
1/3 cup cold water
Almond, vanilla or lemon extract

Using a rotary egg beater or an electric mixer, whip egg whites with sugar, cream of tartar, and water in the top of a double boiler until foamy.

Boil two inches of water in the bottom of the double boiler, then place pot with icing mixture on top of the boiling water. Continue to whip icing mixture for 7 minutes or until firm. Whip in flavoring.

Spread icing on cake over the marzipan.

You can decorate the cake much as the Dickens family would have by using marzipan scraps to fashion tiny people, snowmen, sleds and fruit. Or you can buy candy figures.

CHEESE RAREBIT

*T*oasted Cheese was a delicacy. This savory could be a supper dish or, with a small salad, follow the desserts, fruits and nuts of a large dinner. Charles Dickens especially liked finishing a dinner with Toasted Cheese.

Melted cheese on toast has long been popular throughout the British Isles with local variations: The English traditionally have used Port to soak the bread; the Welsh eliminated the wine but spread mustard over the melted cheese. The Scotch buttered the toast, then toasted a slab of cheese on both sides and placed it on the toasted bread, and served it hot without seasoning.

To do this toasting, a number of pieces of equipment were used. In some cases, the toast and cheese were placed in a tin oven in front of the fire. Other recipes called for a heated "salamander"—a heavy plate of iron on the end of a long handle. The plate was preheated in the fire until it glowed red hot and then held over the dish to broil or toast it. Salamanders were expensive items, and sometimes a heated coal shovel was substituted.

The contemporary cook may use a broiler to make toasted cheese.

An English Rabbit

*C*ut a handsome toast of Bread without Crust, and shave a good Quantity of Cheese very fine.

Set a Tin Oven before the fire, and have in Readiness a Glass of red Port Wine.

Toast the bread carefully on both Sides, then pour the Wine upon it, and turn it.

When it has soaked up the wine spread the scraped Cheese thick upon it, lay it in the Oven, and place it before a good fire; the Cheese will do very quickly and very finely. Send it up very hot.

There are three Ways of toasting cheese: the first is the genuine Method, and those who are fond of Cheese prefer it to either of the others.

One would think nothing could be easier than to toast a Slice of Cheese, and yet not only in private Families but at Taverns we see nothing is done so badly: The Directions here given are easy to be observed, and they will never fail to send it up either Way mellow, hot, well done, and with the bread crisp and soft.

Martha Bradley, *The British Housewife* (London, 1756)

The Modern Cook

Toasted Cheese

8 thick slices of bread, with crusts removed
24 ounces port wine
1 lb. cheese: Stilton or cheddar, grated

Cut thick slabs of bread, remove crusts, and toast on both sides in a broiler.

Pour the wine on the toast quickly.

Spread the cheese thickly atop the toast, and return to the broiler until it is melted.

Serve immediately.

Serves 8

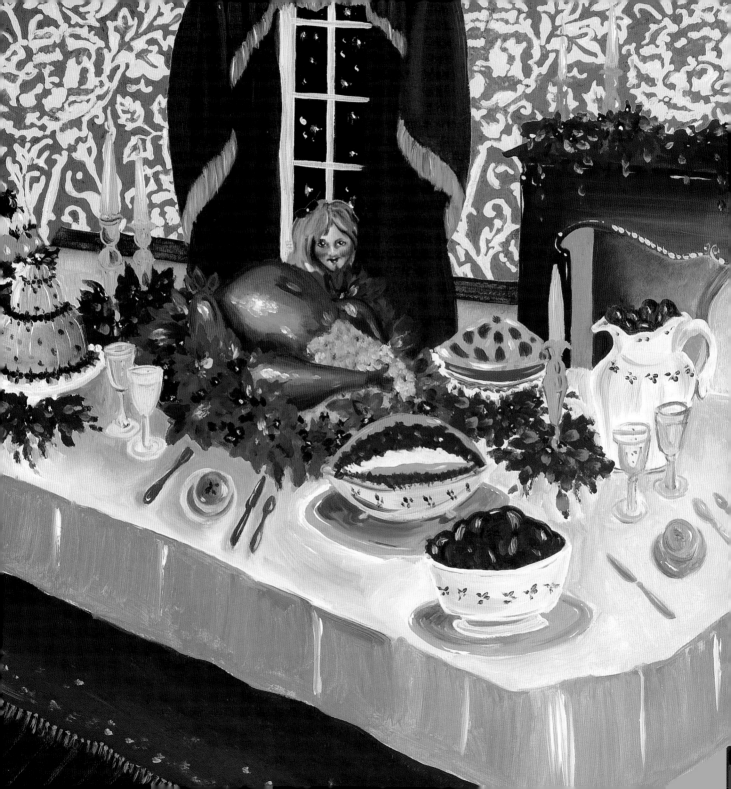